THIS
COLORING
BOOK
BELONGS TO

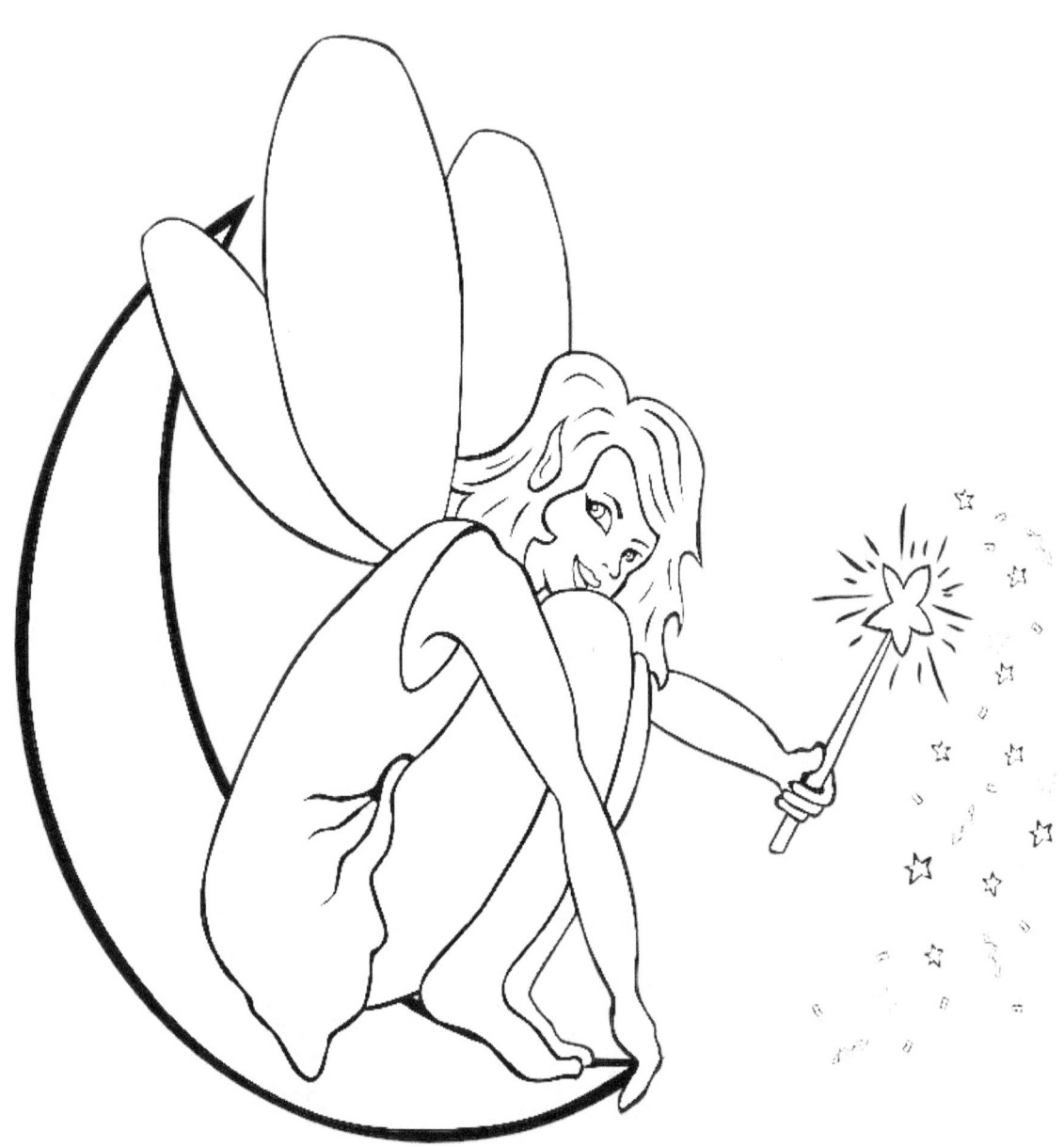

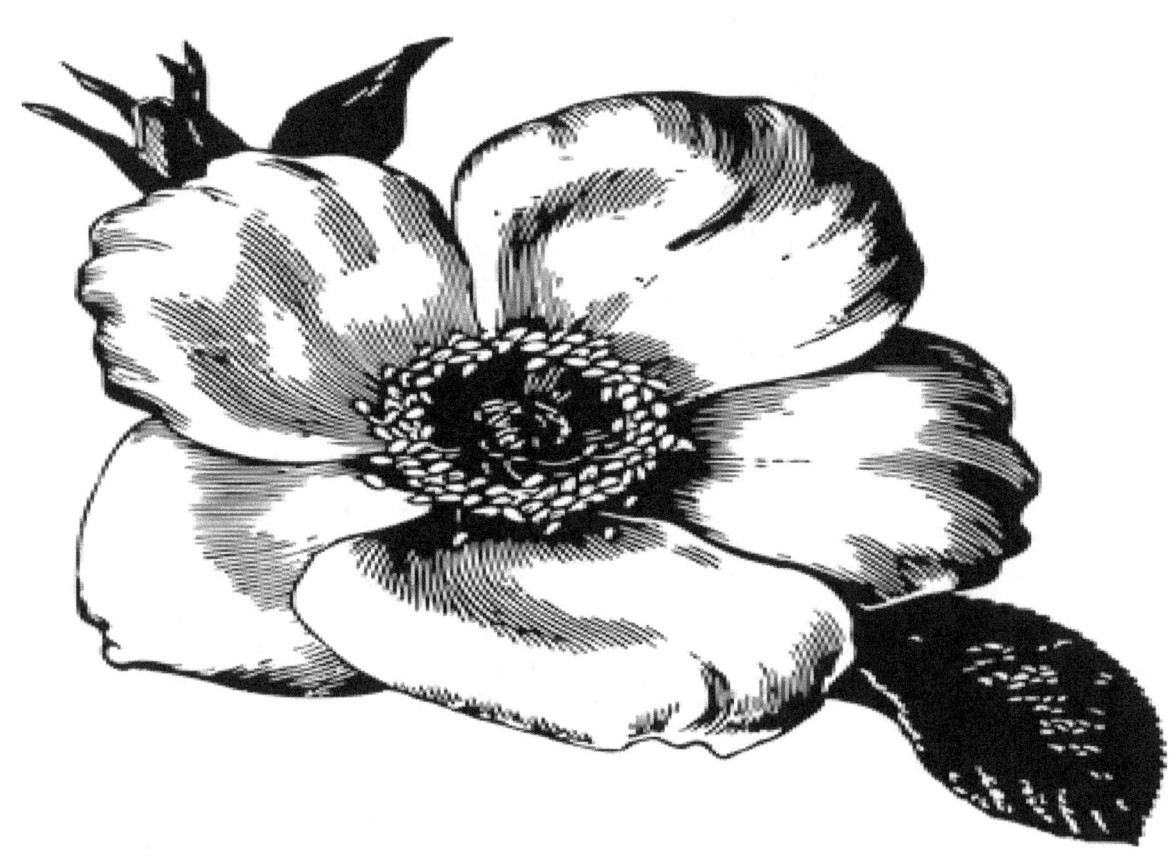

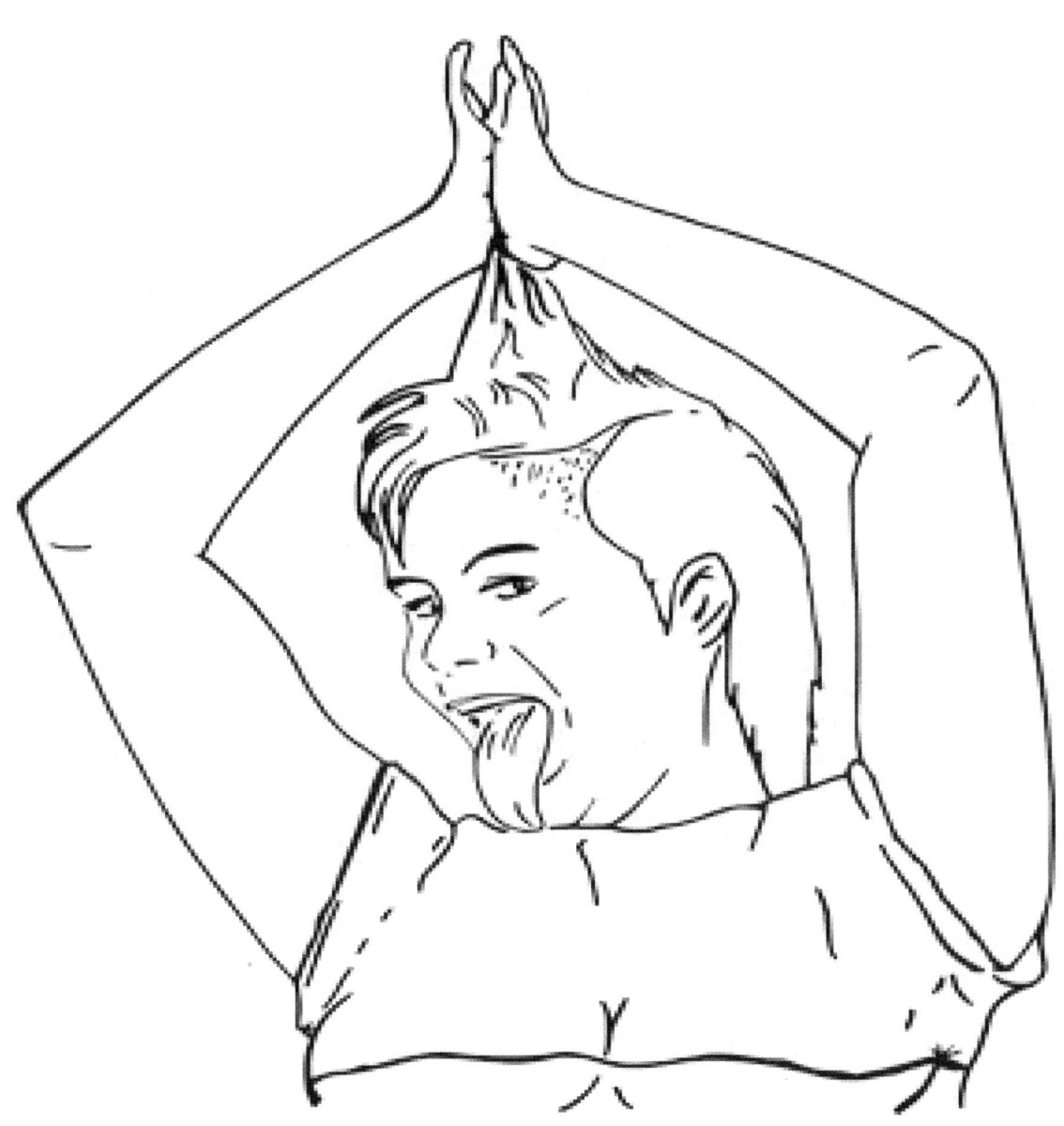

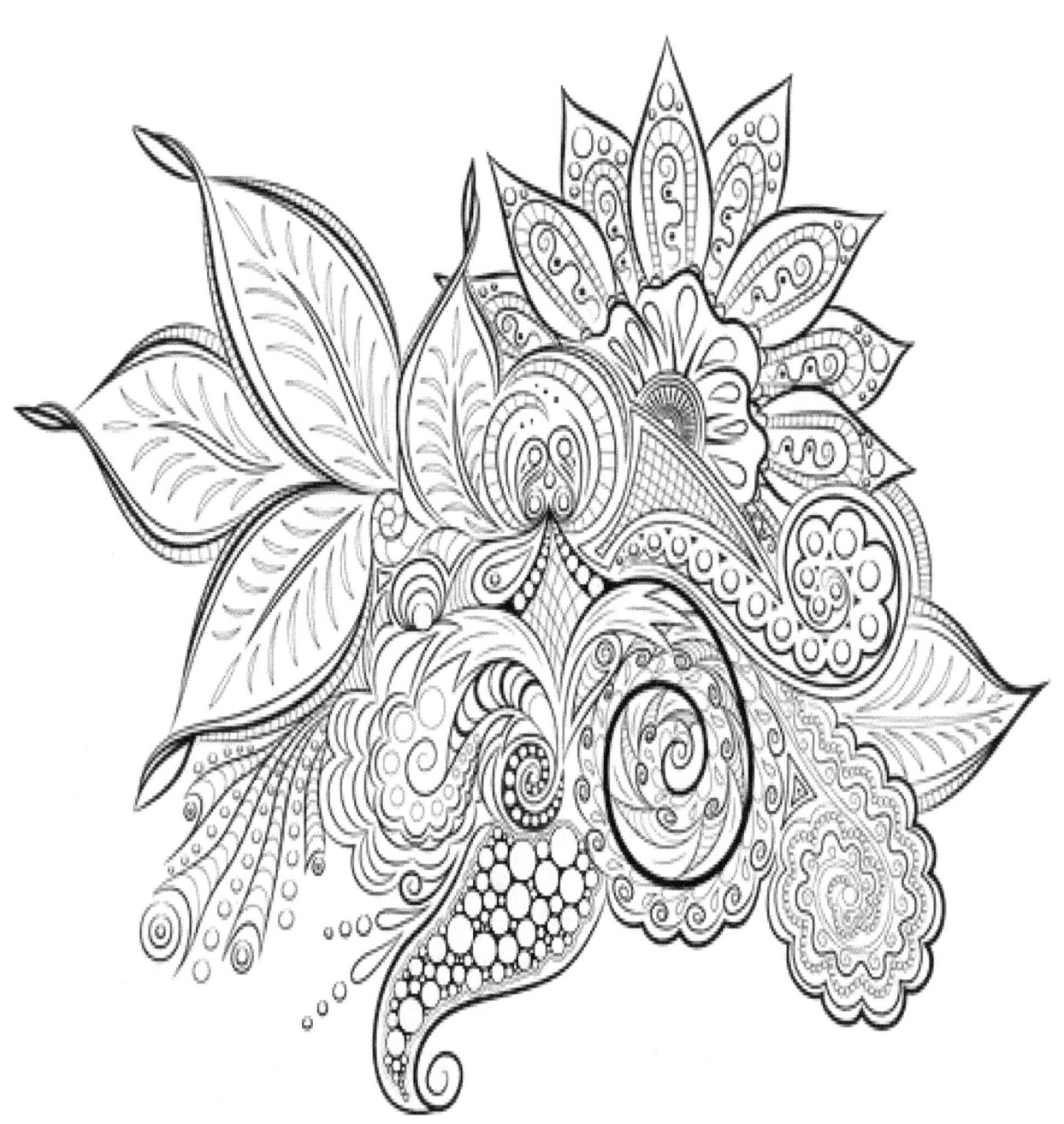

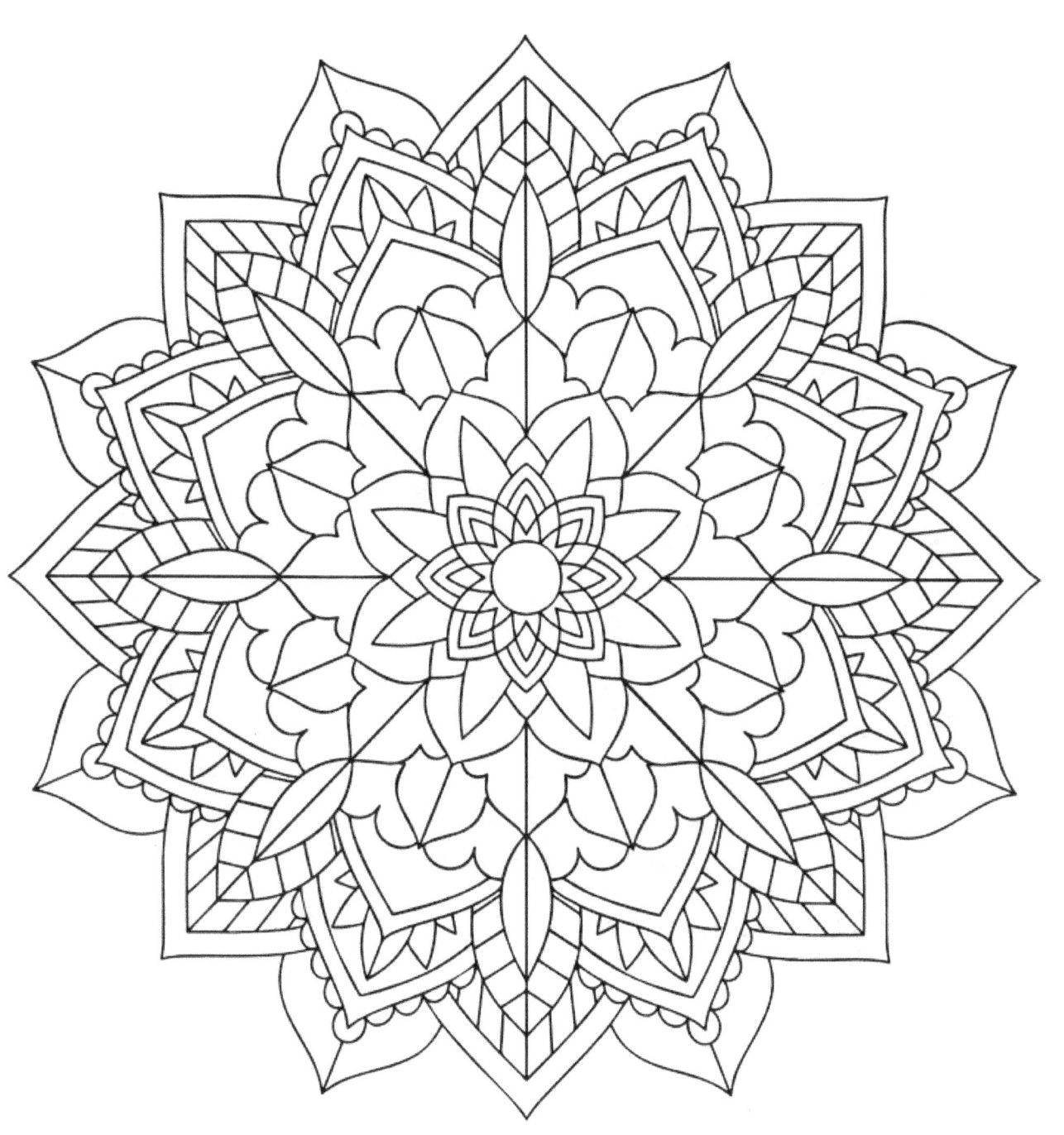

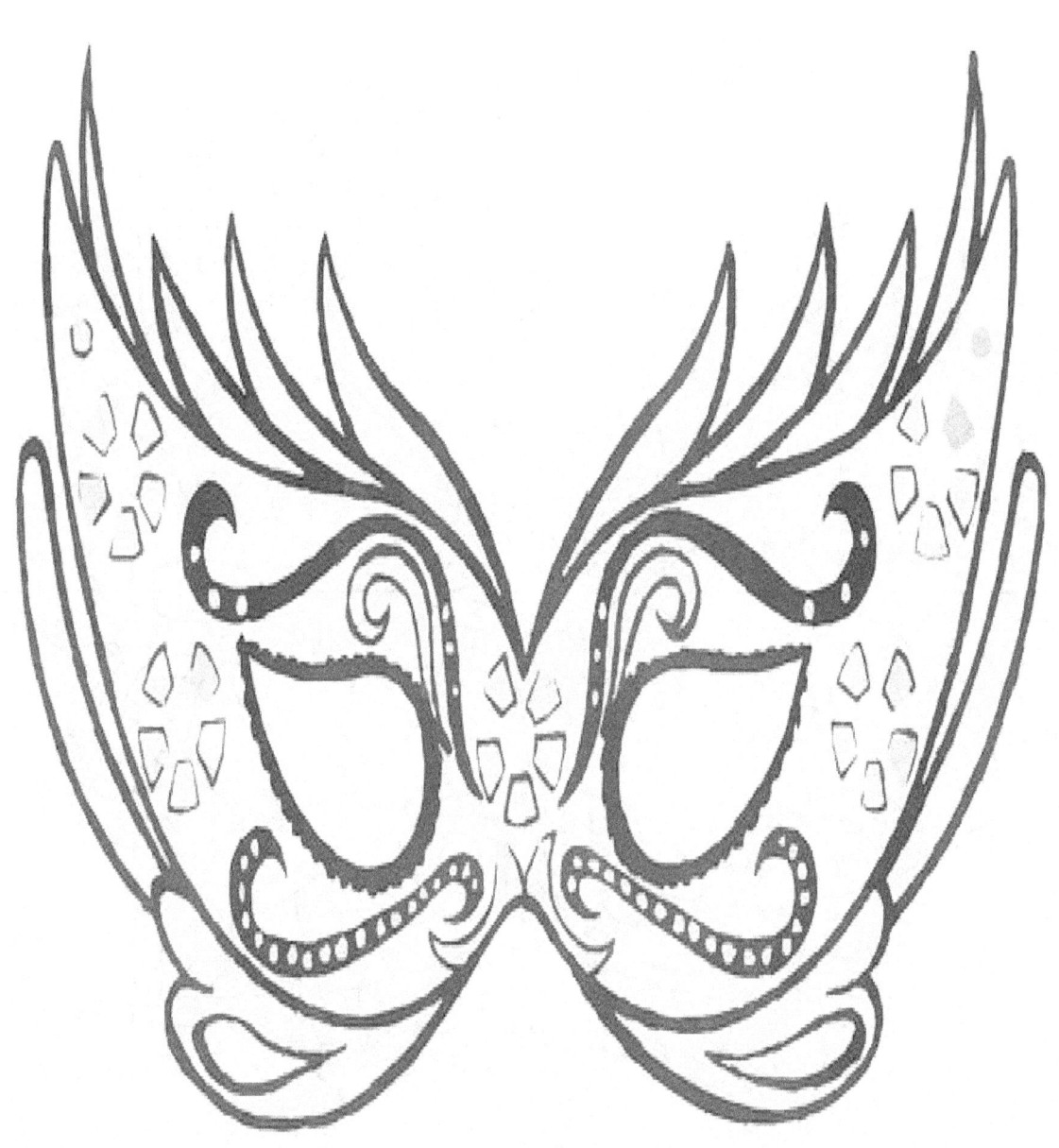

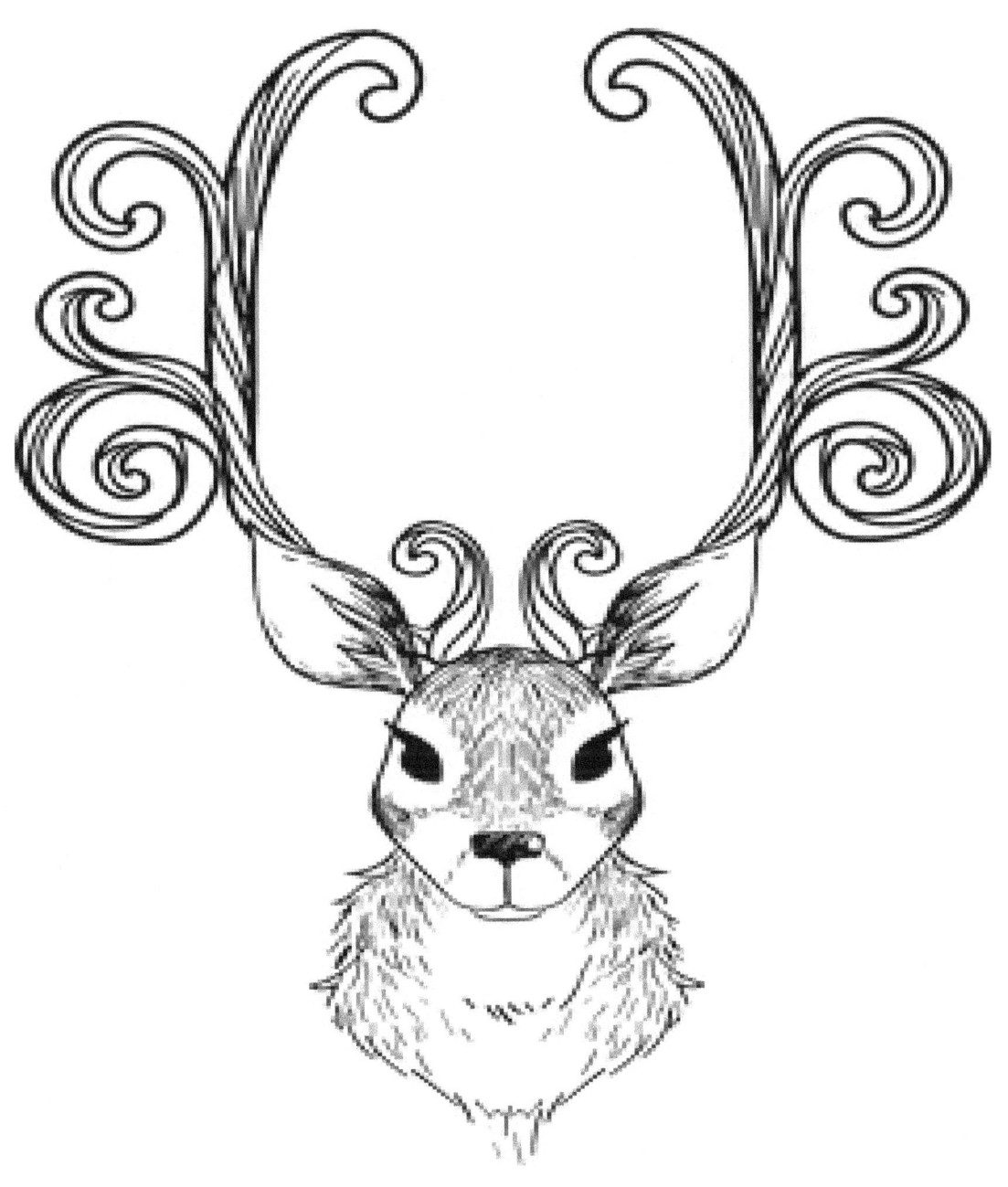

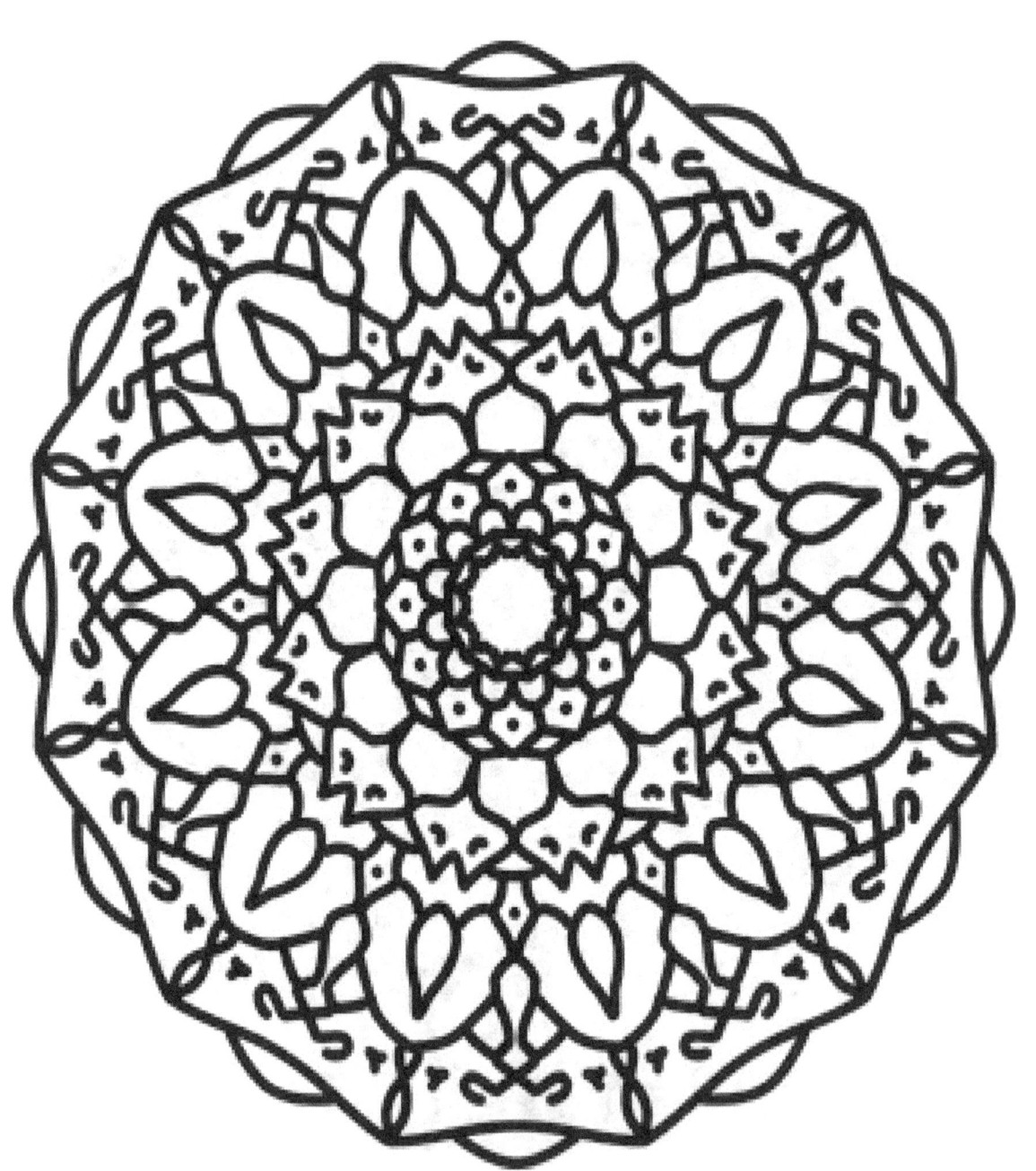

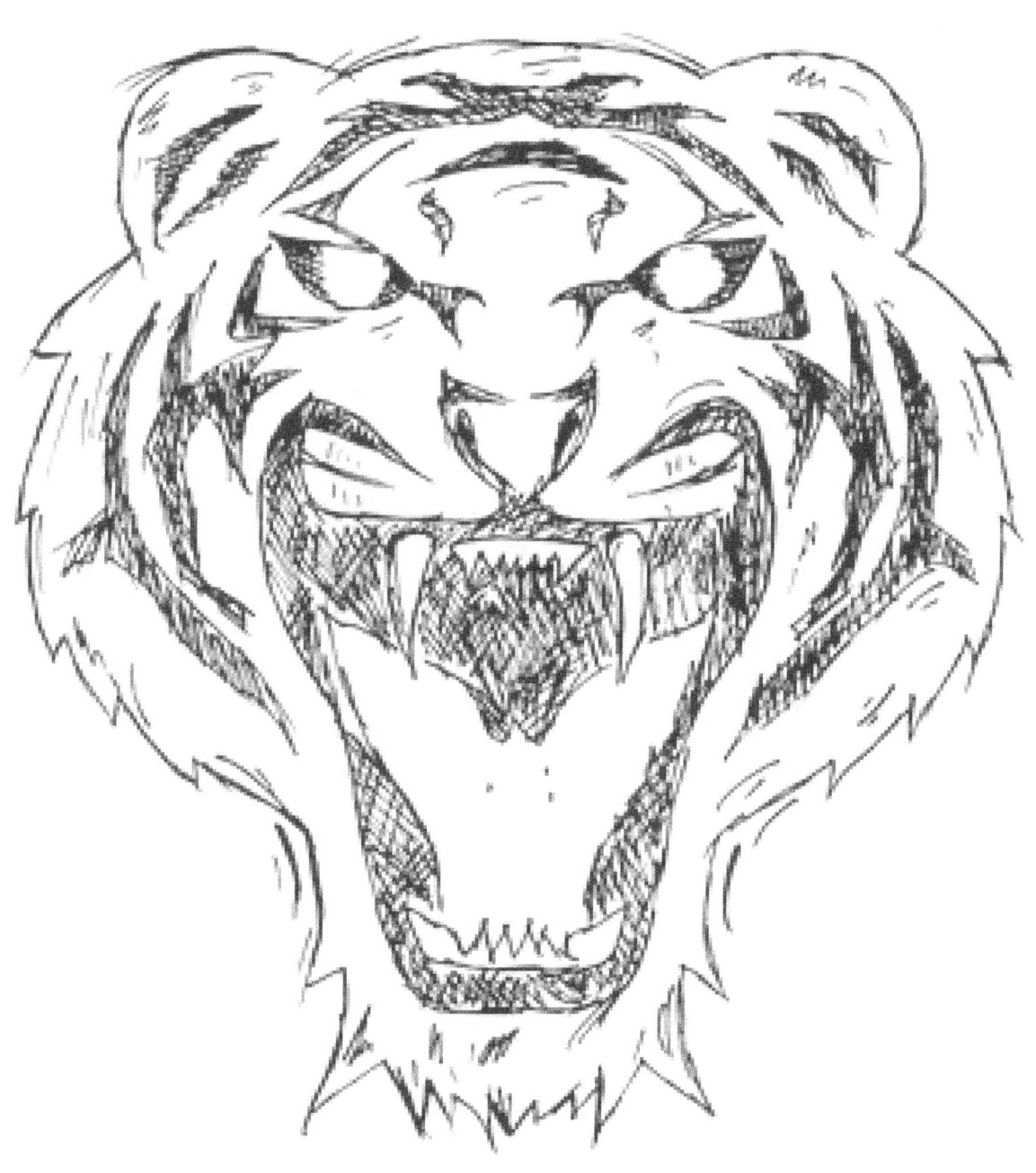

THANK YOU
STAY LIT
AND SWEET

www.ingramcontent.com/pod-product-compliance
Lightning Source LLC
Chambersburg PA
CBHW080618220526
45466CB00010B/3375